Coloring Tools

Using whatever medium you like, you can take these delightful drawings into a new world of color. Different coloring tools can really lend different effects and moods to an illustration— for example, markers make a vibrant statement while colored pencils offer a softer feel. Have fun experimenting with some of these mediums:

- Markers
- Colored pencils
- Colored pens
- Gel pens
- Watercolors
- Crayons

Color by Marie Browning.

Markers
Dual Brush Markers (Tombow).
Bright Tones.

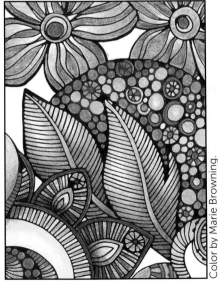

Color by Marie Browning.

Colored Pencils
Irojiten Colored Pencils (Tombow).
Vivid Tones.

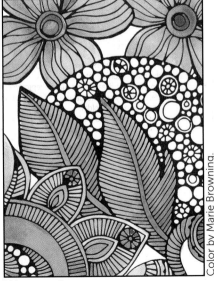

Color by Marie Browning.

Watercolors
Watercolors (Winsor & Newton).
Analogous Tones.

Color Theory

With color, illustrations take on a life of their own. Remember: when it comes to painting and coloring, there are no rules. The most fun part is to play with color, relax, and enjoy the process and the beautiful finished result. Feel free to mix and match colors and tones. Work your way from primary colors to secondary colors to tertiary colors, combining different tones to create all kinds of different effects. If you aren't familiar with color theory, here is a quick, easy guide to the basic colors and combinations you will be able to create.

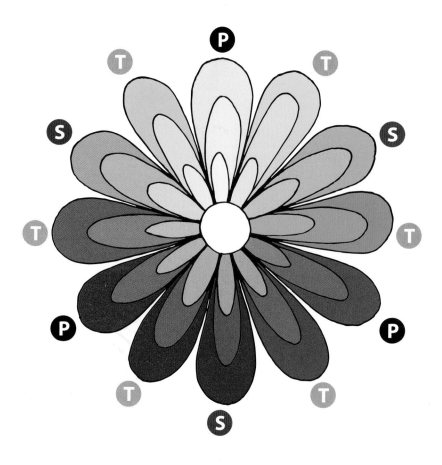

Primary colors: These are the colors that cannot be obtained by mixing any other colors; they are yellow, blue, and red.

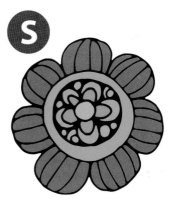

Secondary colors: These colors are obtained by mixing two primary colors in equal parts; they are green, purple, and orange.

Tertiary colors: These colors are obtained by mixing one primary color and one secondary color.

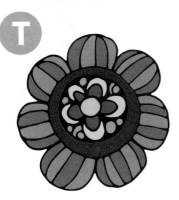

Coloring Ideas

Color each section of the drawing (every general area, not every tiny shape) in one single color. This will take less time and can change the overall look of the drawing.

Within each section, color each detail (small shape) in alternating colors. This creates a nice varied and symmetrical effect.

Leave some areas white to add a sense of space and lightness to the illustration. Just because it's there doesn't mean it has to be colored!

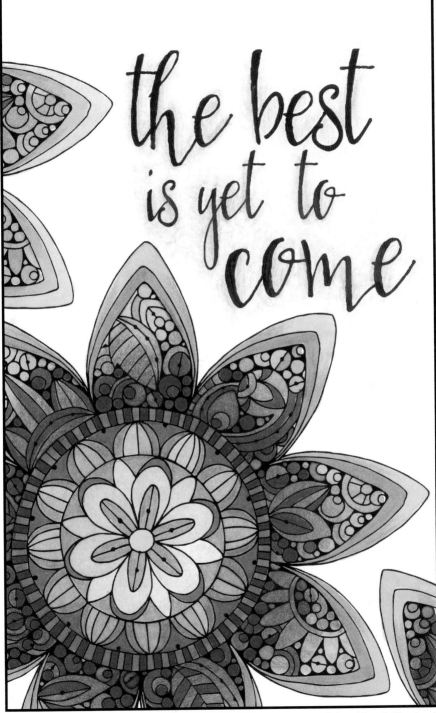

the best
is yet to
come

Watercolors (Winsor & Newton), Irojiten Colored Pencils (Tombow).
Bright tones. Color by Marie Browning.

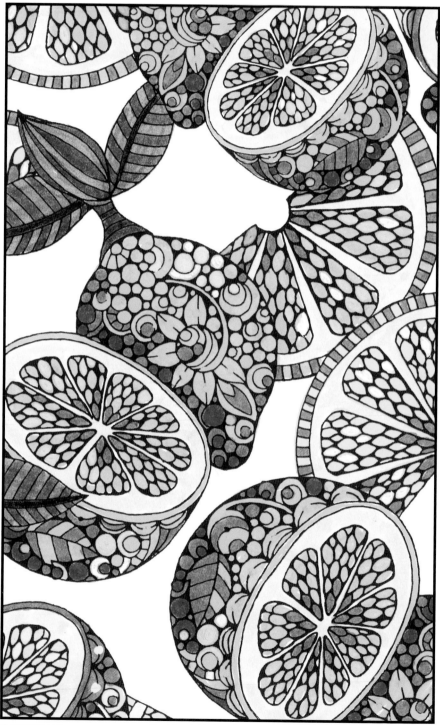

Dual Brush Markers (Tombow), Gel Pens (Sakura). Vivid citrus tones.
Color by Marie Browning.

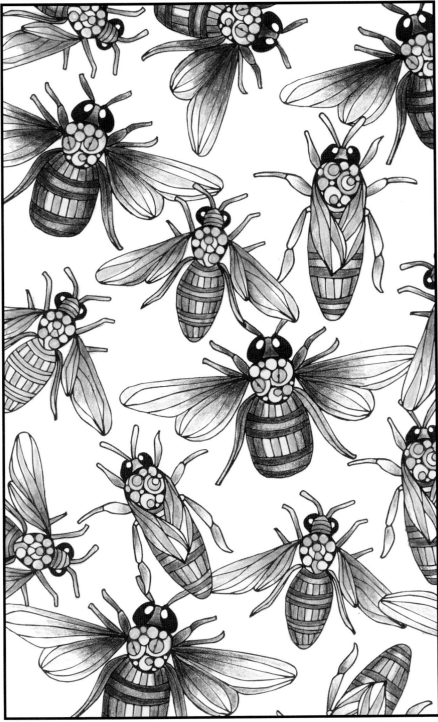

Dual Brush Markers (Tombow), Irojiten Colored Pencils (Tombow).
Jewel tones. Color by Marie Browning.

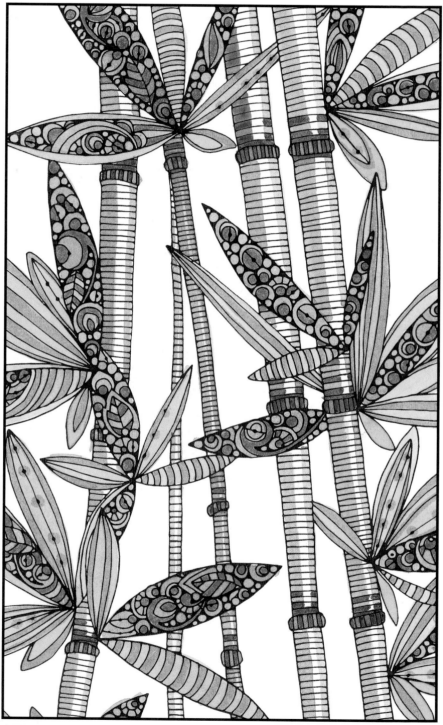

Irojiten Colored Pencils (Tombow). Analogous warm tones.
Color by Marie Browning.

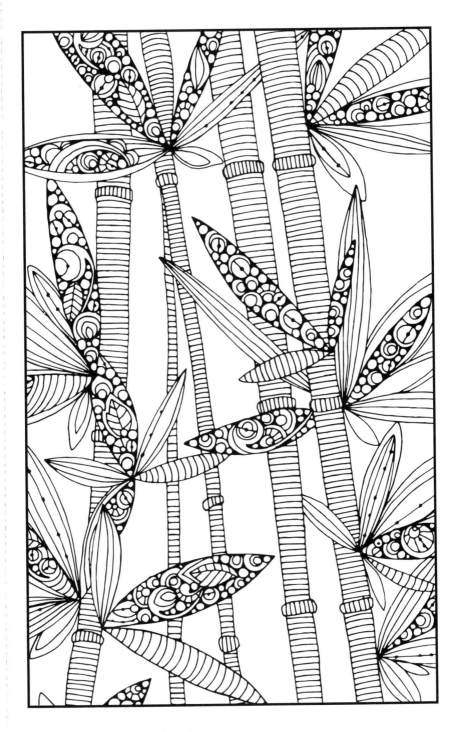

There is always music amongst the trees in the garden, but our hearts must be very quiet to hear it.

—Minnie Aumonier

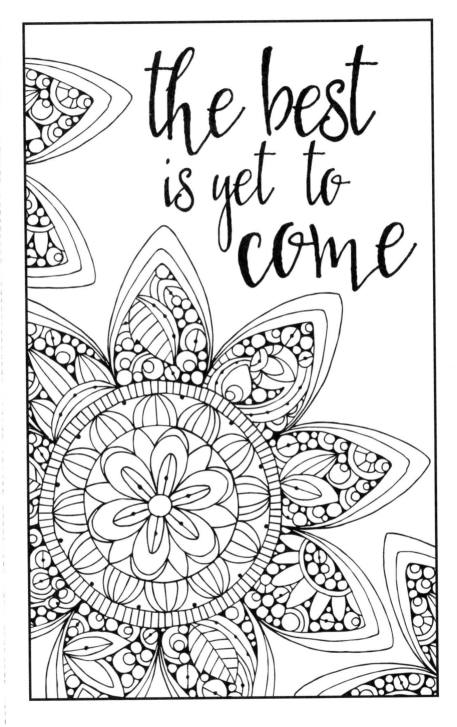

For my part I know nothing with any certainty, but the sight of the stars makes me dream.

—Vincent van Gogh

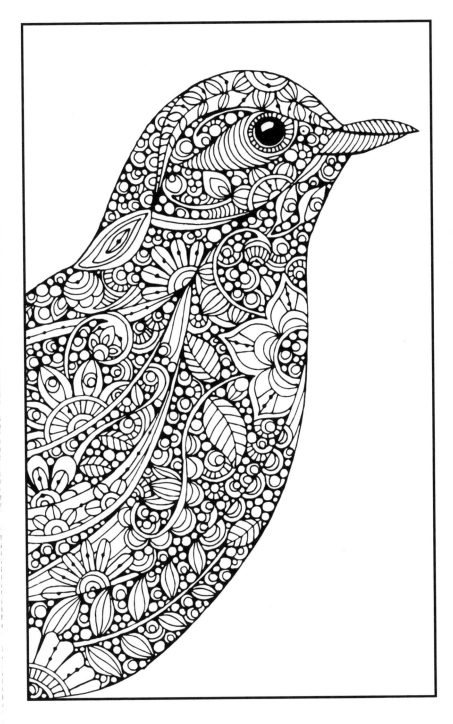

The earth has music for those who listen.

—George Santayana

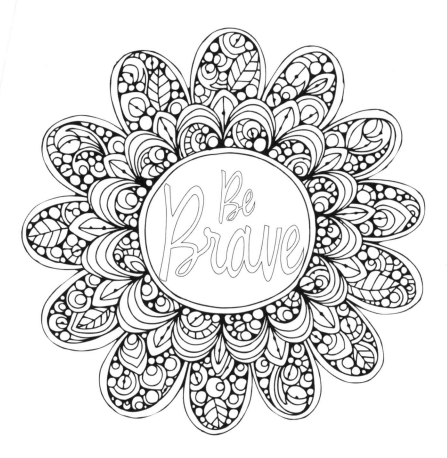

Do one thing every day that scares you.

—Mary Schmich

Nature is not a place to visit. It is home.

—Gary Snyder

© Valentina Harper, www.valentinadesign.com

May your joys be as deep as the ocean,
your sorrows as light as its foam.

—Unknown

That it will never come again
is what makes life so sweet.

—Emily Dickinson

Your head is a living forest full of songbirds.

—e. e. cummings

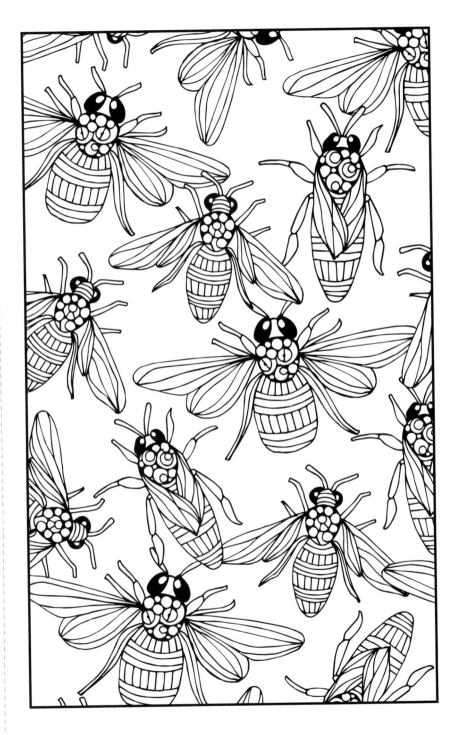

Float like a butterfly, sting like a bee.

—Mohammad Ali

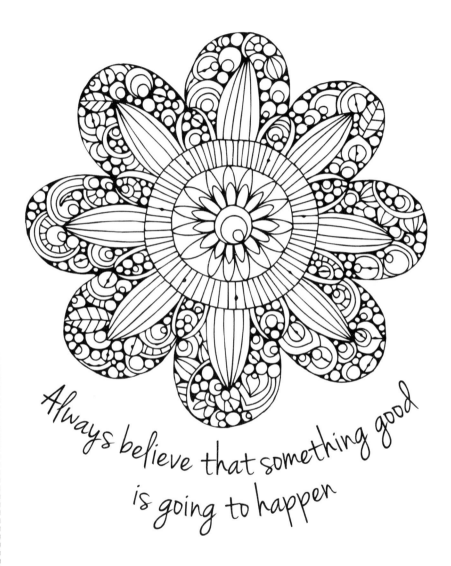

Always believe that something good
is going to happen

Joy is what happens to us
when we allow ourselves to recognize
how good things really are.

—Marianne Williamson

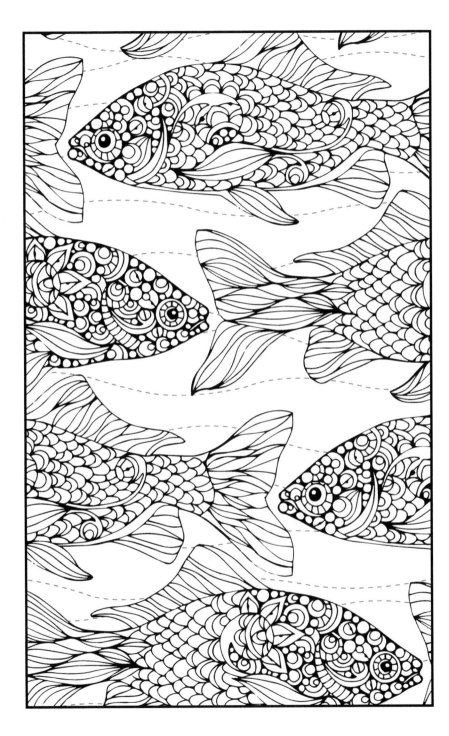

When life gets you down, do you wanna know what you've gotta do? Just keep swimming.

—Dory, *Finding Nemo*

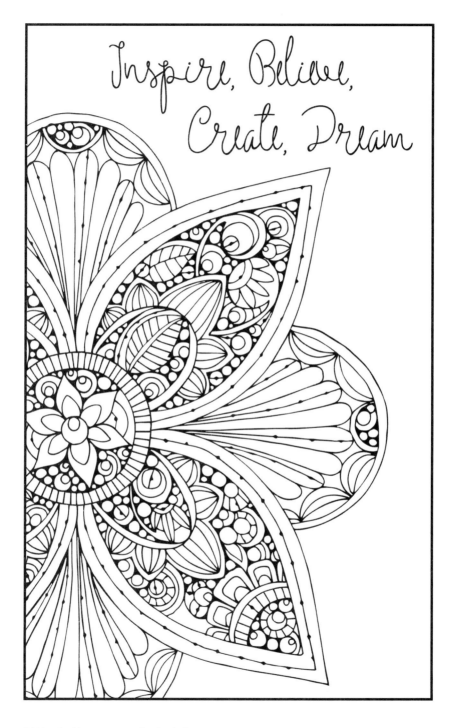

Inspire, Believe, Create, Dream

The future depends on what you do today.

—Mahatma Gandhi

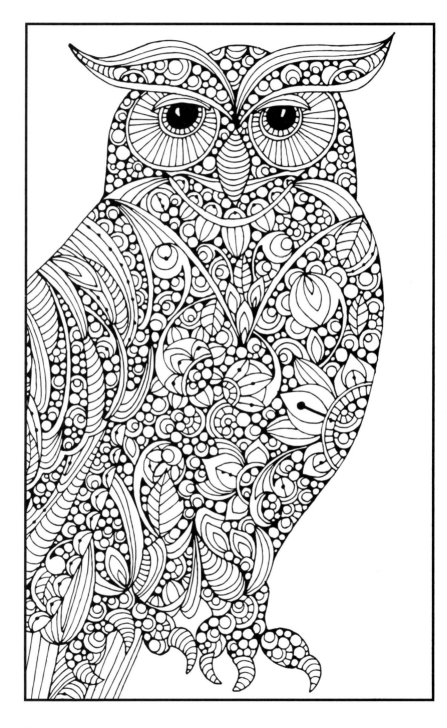

No bird soars too high,
if he soars with his own wings.

—**William Blake**

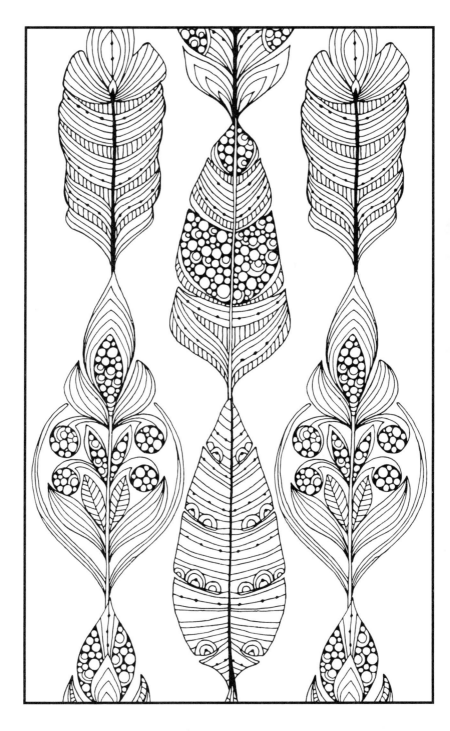

A bird is three things:
Feathers, flight and song,
And feathers are the least of these.

—Marjorie Allen Seiffert, *The Shining Bird*

Be the change that you wish to see in the world

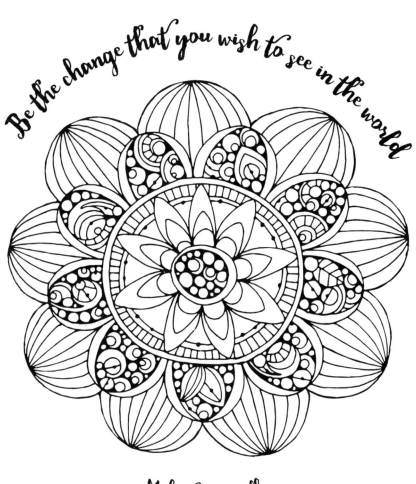

Mahatma Gandhi

Sometimes in the waves of change
we find our true direction.

—Unknown

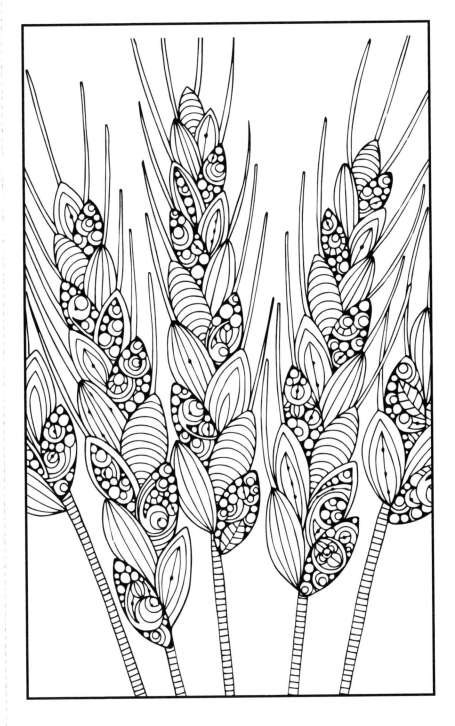

Nothing is worth more than this day.

—Johann Wolfgang von Goethe

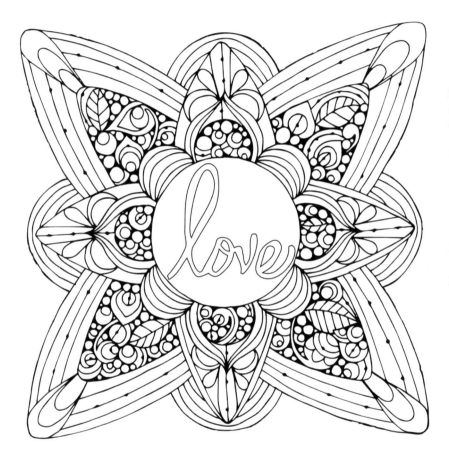

This is what my soul is telling me:
Be peaceful and love everyone.

—Malala Yousafzai

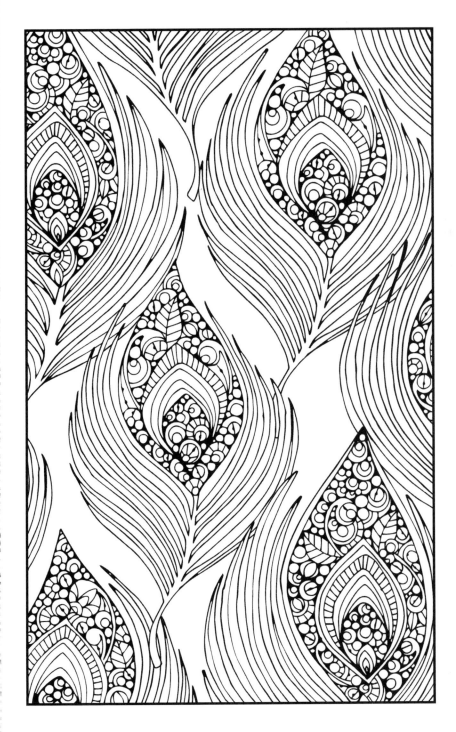

Looking at beauty in the world
is the first step of purifying the mind.

—Amit Ray

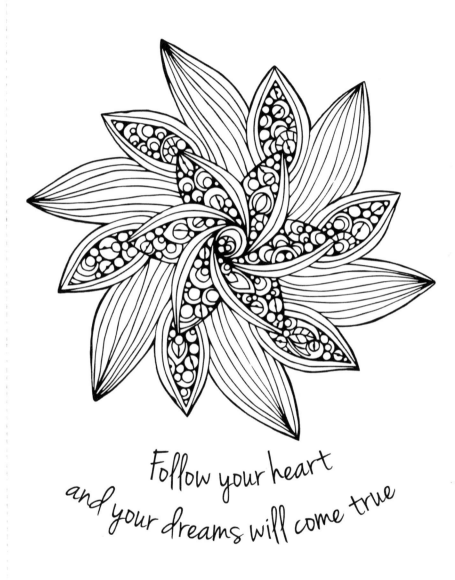

Follow your heart
and your dreams will come true

Always listen to your heart,
because even though it's on your
left side, it's always right.

—The Notebook

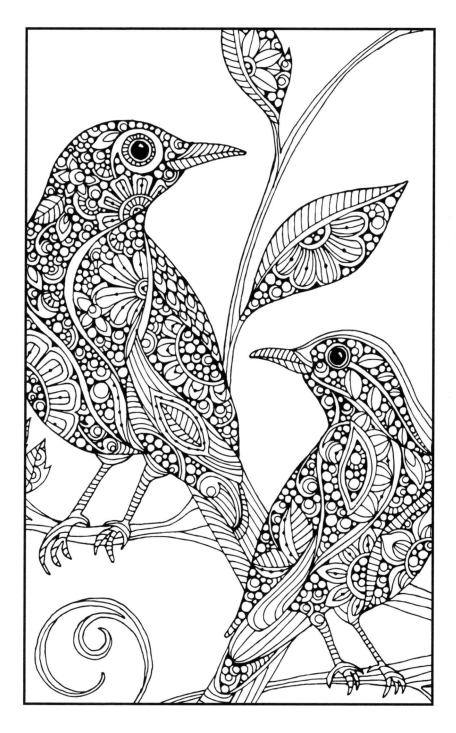

A friend is someone who knows the
song in your heart, and can sing it back to
you when you have forgotten the words.

—Unknown

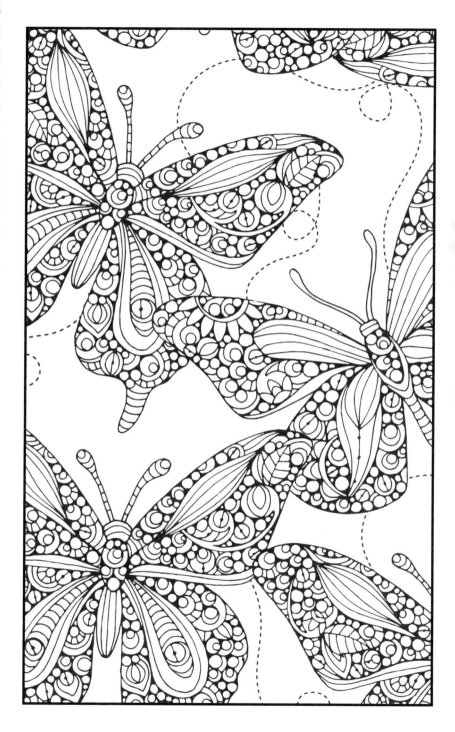

If nothing ever changed,
there would be no butterflies.

—Unknown

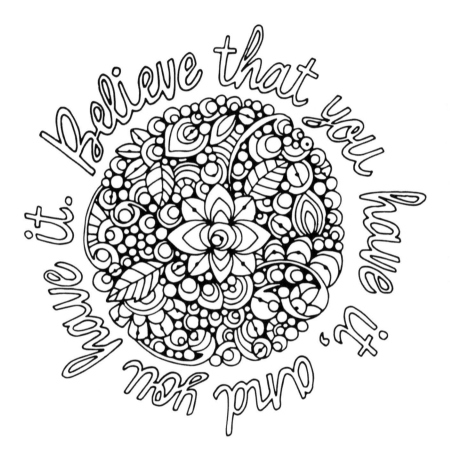

Believe that you have it, and you have it.

It is better to know and be disappointed than to never know and always wonder.

—Unknown

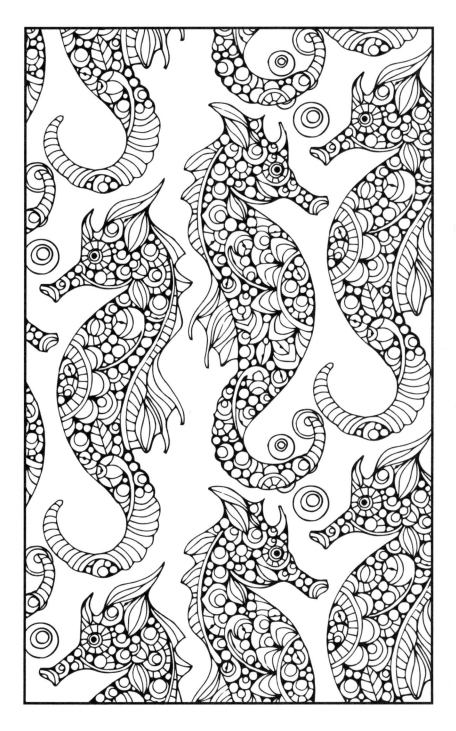

The ocean stirs the heart,
inspires the imagination,
and brings eternal joy to the soul.

—Wyland

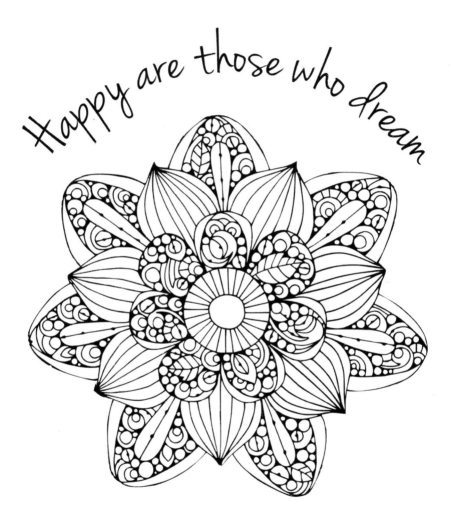

Happy are those who dream

Happiness is not a station you arrive at,
but a manner of traveling.

—Margaret Lee Runbeck

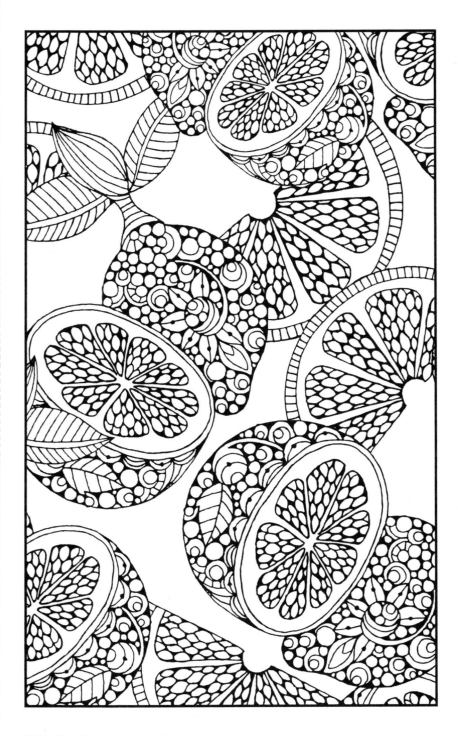

Patience is bitter, but its fruit is sweet.

—Jean Chardin

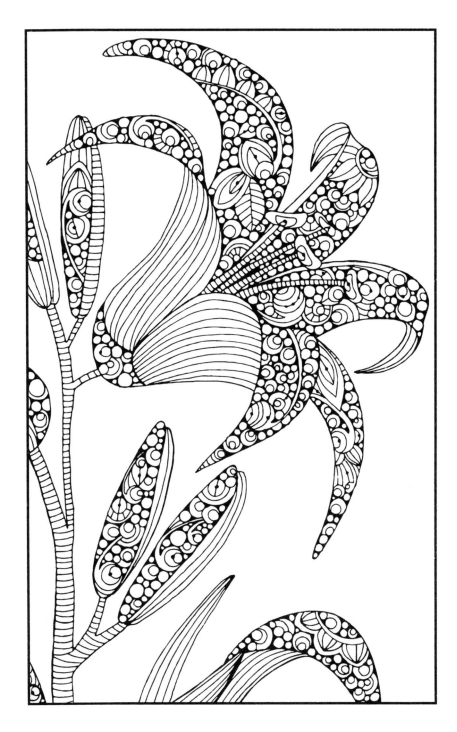

© Valentina Harper, www.valentinadesign.com

There is a pleasure in the pathless woods,
There is a rapture on the lonely shore,
There is society where none intrudes,
By the deep Sea, and music in its roar:
I love not Man the less, but Nature more.

—George Gordon Byron, *Childe Harold's Pilgrimage*